A PAINTER'S PSALM

The Mural in
Walter Anderson's Cottage

by **Redding S. Sugg, Jr.**

with photographs by Gil Michael

MEMPHIS STATE UNIVERSITY PRESS

Sugg, Redding S., Jr.,
A PAINTER'S PSALM:
THE MURAL IN WALTER ANDERSON'S COTTAGE
ISBN 0-87870-046-3

A PAINTER'S PSALM

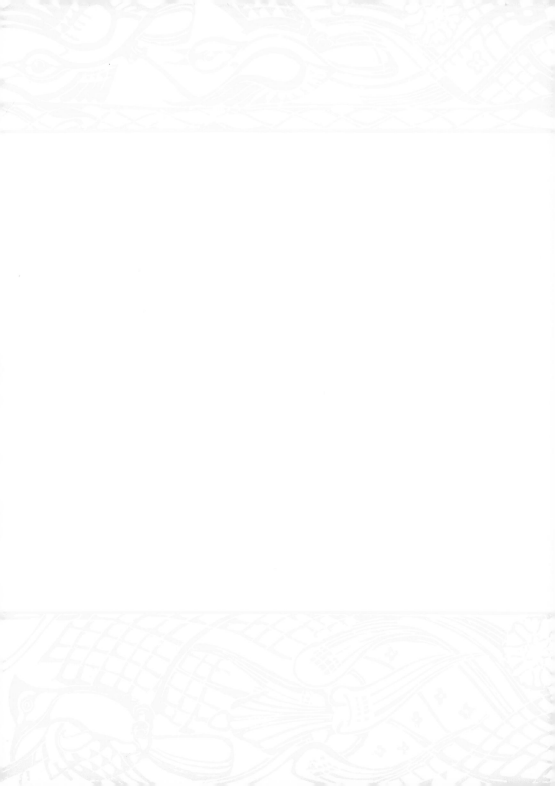

T

he mural by the late Walter Inglis Anderson presented photographically in this little book should be approached as an element of its setting, the Mississippi Gulf Coast, to which the painter made himself a rapt witness and from which he derived the images that he declared were as bread and meat to him. Located in the cottage where he lived in Ocean Springs, the room containing the mural measures only 12 by 14 feet. It impresses people as compacted riches both material and spiritual. Viewers coming upon it for the first time are likely to compare the room with a jewel cabinet or some sanctum sanctorum. They think of a painted funerary chamber deep in an Egyptian tomb or of a lavishly frescoed lady chapel in a medieval Roman Catholic church. The mural is, in fact, an essence of the place extracted by a lover, a compendium of the *très riches heures* of an immensely gifted artist-naturalist. His exclusive, withdrawn, but nevertheless prophetic experience of life there began to speak through his works to a public, still few but growing, only after he died in 1965.

The sense of the mural's being set apart imposes itself first from the physical approach to the cottage and then by the unexpectedness of treasure at the end. The visitor approaches by turning off the public thoroughfare, Shearwater Drive, and penetrating a private drive which tunnels through semi-tropical vegetation. The cottage, a simple antebellum structure in white clapboard, originally built as slave quarters, stands among boles of towering pine and spreading oak, bowered in the foliage of lower shrubs and trees, azalea, dogwood, and swamp magnolia (Plate 1).

Plate 1
Exterior view of Walter Anderson's cottage as it looked in 1976.

Acknowledgments

In preparing this little book, as was also the case with the earlier book and two magazine articles I have published on Walter Inglis Anderson, I was dependent upon the gracious cooperation of his widow, Agnes Grinstead Anderson.

James D. Simmons, now Assistant Director of the University of Southern Illinois Press, took, while Director of the Memphis State University Press, a personal interest in the project, especially in the photographing of Anderson's mural. Himself professionally trained in film, he worked with Gil Michael, whose skill in making the photographs is acknowledged in the text, and me to achieve not only the most faithful possible reproduction of the subject but also to produce a book of aesthetic and technical interest to students of photography.

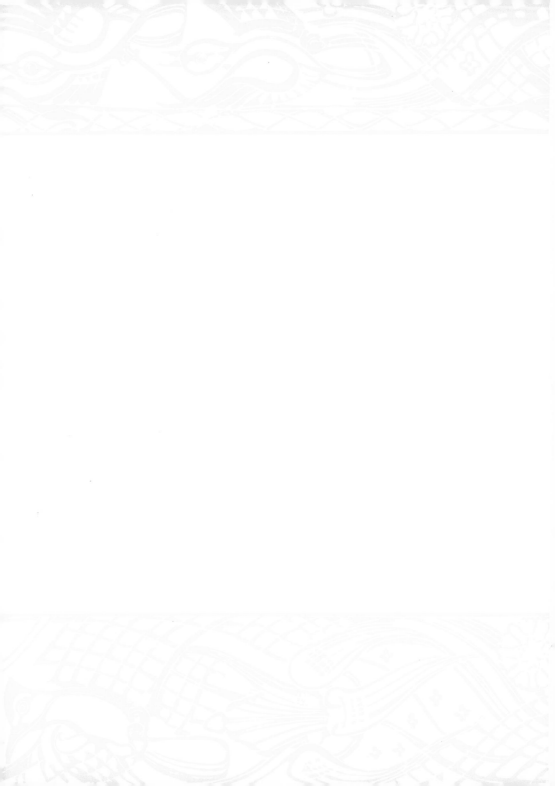

Anderson and his wife lived here beginning in 1933. Following the births of two children, they added the little room in 1939. In the meantime, Anderson had fallen mentally ill and was hospitalized. The cottage was occupied by the family off and on until 1941, when they moved to Oldfields, the home of Mrs. Anderson's father, near Gautier. Walter Anderson returned alone to the cottage in 1947 and lived there a recluse until he died. He began the mural probably about 1961 and left it unfinished, although near enough completion to make its effect. During the later years of his tenancy, the approach to the cottage was barred, with symbolic emphasis, by a tangle of Cherokee rose. In the earlier time, before mental illness had led him into the paths of alienation, Anderson had built an arbor over the short path from the drive to the front door and planted the rose upon it. Having become, as he once named himself, "the Alienado," he let the rose luxuriate into a forbidding zone of thorn through which he rarely invited anyone.

So it was that, although a few persons had glimpses of the mural in progress, nobody had any conception of it until the cottage was opened after he died. The cottage proved to contain a wealth of drawings, paintings (mostly watercolors), and writings in a jumble which required time to sort and assess, a task not entirely completed even now. Although the best defended item in the trove, Anderson having left the door to his little painted room padlocked, the mural was the largest and most immediately appreciable. It burst upon the Anderson family, bereaved and thinking they had to do only with the liquidation of the remains of a tragically aborted talent, as a note of affirmation, as exhilarating as it

was unexpected.

His sister-in-law and blood sister to his wife, Mrs. Peter Anderson, exclaimed at that discovery, "Why, it is the Creation at sunrise!" This phrase has been used informally as a title for the work because it expresses the joyous effect of it. The phrase applies, however, to only one wall and tends to restrict appreciation of the total design. Plate 2 illustrates the initial impact of the room, which registers strongly on even the casual visitor without personal connection to the painter or knowledge of his life.

Nevertheless, a work so intensely private raises questions of both an ethical and an aesthetic nature: is one intruding; are the motifs intelligible? The mural is undoubtedly the penetralia of a man's castle, his mind, his character; the expression of a man who had so little of a normal kind to say to the world that he did not even write a will. But although in a legal sense Walter Anderson died intestate, the mural is a work of art, and as such a testament of beauty inviting the beholder. The family's initial reaction, echoed by that of viewers since, has confirmed this aspect of the work. It will be the chief purpose here to develop the aesthetic value of the mural by explaining the significance of the work and stressing its bearings on tradition, which guarantee its public meaning.

Anderson was extremely ambivalent about selling or exhibiting his work—drawings, watercolors, and surely the cottage mural—that most directly expressed his painterly commitment. He was likely to state his occupation when he had to, as, for example, in his passport, not as artist or painter but as "decorator." In that capacity, and with an eye to the market, he designed pottery, now

much sought by collectors, for production in his brother Peter's nearby Shearwater Pottery, and linoleum block prints. His paintings, as readers of *The Horn Island Logs of Walter Inglis Anderson* (1973) will know, were private affairs conducted on principles very different from those of artists who aim for reputation. In relation to the mural, however, he left persuasive circumstantial evidence, though no explicit statement, of the theme he intended, and that theme is classic.

Under the south casements of the little painted room, the Anderson family found a cardboard carton filled with writings. These proved to be all by Anderson—essays, fables, verse, obiter dicta—except one item, which was a copy in his hand of Psalm CIV in the King James Version. He also left locked in the room, by way of enhancing its effect as a vault for valuables, a small wood chest he had carved and in which he had stored about 2,000 of his watercolors in their jewel-like hues. The mural, as is obvious on first inspection, is a representation of the Gulf Coast scene filled with local flora and fauna. The watercolors are, in effect, exquisitely rendered details supplementing those on the walls. At a second glance, one realizes that Anderson organized the mural according to the successive phases of light during the course of a day. Beginning with the east wall and following around to the north, he painted segments of the mural in the light of dawn, sunrise, morning, noon, afternoon, evening, and night. This organization parallels and, I believe, may reasonably be taken as conscious allusion on Anderson's part to the organization of Psalm CIV.

I shall deal with the mural descriptively but call upon the circumstantial evidence wherever this seems to illuminate it. The

mural may be interpreted in the light of Anderson's writings, chiefly the logs he kept of expeditions to paint and naturalize but others as well, of other paintings and sculpture by him, and of his biography. While these sources reveal much that is merely personal to the artist in the work, they also tend to reinforce the argument which relates the mural to the psalm. Although not in a detailed way an illustration of the psalm, the mural can be interpreted not only as indebted to the psalm for principles of organization, but also as a distinctive affirmation in a painter's medium of the psalmist's ecstatic vow, "I will sing unto the Lord . . . while I have my being."

In speaking of various approaches to the mural, I should like to remind readers of yet one more of peculiar revelance to this book: the photographer's. Gil Michael set himself to provide, as nearly as photographic technique and the conditions under which he had to work permitted, an accurate representation free of subjective and interpretative effects. His pictures are intended to give readers something approximating actual experience. Nevertheless, the camera creates certain distortions, especially of perspective in so small a space. This is apparent, for example, in Plate 2, in which the room seems to be larger and deeper than it is. The camera could not capture exactly the dimensions as the visitor first apprehends them on entering or the peculiarly Andersonian effect of being immersed in images which the visitor registers when standing within the room. But photography also brings advantages over actual experience through control of lighting and focus on details. Michael has succeeded notably also in obtaining faithful reproduction of the colors.

Plate 2
General view of room with mural.

To return to the mural: the visitor who approaches Anderson's cottage today passes only the vestiges of the Cherokee rose arbor and enters a structure which, for all its history as the hermitage of eccentric genius, has nothing of the repellent aspect of an anchorite's cave, just as the lush setting makes no allusion to the anchorite's arid desert. The cottage, though in need of restoration, is still the charmingly remodeled and decorated home Anderson prepared for his married life. As part of restoration, the arbor might be replaced appropriately as the pruned and inviting canopy at the entrance it was first meant to be. Then the mural would be more readily grasped as Anderson's last touch to domestic decoration applied at the end of his life in an affecting qualification of the years of alienation.

When his parents gave it to him and his bride, the cottage comprised two fair-sized rooms with front and rear galleries. He made a comfortable screened porch of the front gallery, and incorporated the rear one into the house to make a bath and dressing room, a well-lighted space for painting, and a kitchen. By removing the partition dividing the two original rooms, he made a space approximately 15' x 30' with high ceilings, a fireplace at the south end and French casements at the other. Between the screened porch on the front and the newly enclosed rooms on the rear and the large central room, he installed sets of sliding double garage doors made of wood panelling. The house can be opened to the air, often needed in that hot, humid climate, in a fashion reminiscent of Japanese construction.

In the main room, Anderson panelled the walls and ceiling with 4' x 8' sheets of ordinary plywood, covered the joints with

narrow boards, and stained the whole a silvery grey, delightful in the green atmosphere beneath the trees. He used red brick and glazed black brick for the fireplace and chimney, later painting it white and blue, and built in the furniture. Against the long sides, he built in bunks that doubled as seating, desks for himself and his wife, and bookcases. Under the casements opposite the fireplace he installed window seats, and he designed and carved furniture for seating by the hearth and for dining by the windows. The cottage was almost entirely furnished and decorated with products of his hand: paintings, pottery, prints, rugs that he hooked, and wood sculptures.

The room in which he much later painted the mural was added as a nursery six years after the Andersons married. One enters from the main room by a door to the left of the fireplace. Before one can register subject and design, one is affected primarily by color and overall, possibly abstract or semi-abstract, patterning. Then one realizes that Anderson has filled the walls and ceiling with paintings of Gulf Coast flora and fauna.

One turns to discover that the fourth wall, bisected by the plastered back—once the exterior—of the chimney and fireplace, is a departure from the landscape that fills the other three. It is painted a dark bluish-black against which a variety of moths, huge in the scale of the first three walls, is displayed. The back of the chimney and fireplace rises before this backdrop with the effect of a large piece of furniture set against wallpaper with a large, splotchy pattern. On the chimney Anderson has sketched but left unfinished a female, possibly devine, figure. This dominates the room and stands on a par with Psalm CIV as a key to the meaning

of the mural, contributing incidentally to the feeling many people have that the room is a sort of lady chapel. The explication of this figure must remain somewhat speculative since Anderson left no word as to his intention; but from knowledge of his life, ideas, and other work, I believe a reasonable account may be inferred.

The walls and ceiling are finished with closely joined boards. I have not obtained an analysis of the paint Anderson used, but it appears to be an oil paint; Mrs. Anderson believes he used the pigments sold for mixing ordinary house paints. He applied these in painting the sections of the mural done on wood but presumably used a different medium, such as would be suitable for frescoing, on the plastered chimney.

One's initial survey comes to an end with a look at the ceiling, which is almost entirely taken up by an open zinnia centered on the electric light bulb, suggesting a disproportionately large plaster medallion of the sort from which chandeliers are hung. Like the north wall, the ceiling is not entirely finished; but the zinnia is completely drawn, and enough of the color has been applied for us to know it was to be a rich magenta. He was working with reddish-pink and blue, outlined in gold, which stresses the symbolic value of this flower. Given the organization of the mural according to the different hours of the day, the zinnia symbolizes the sun at zenith. A further meaning that it had for Anderson emerges from a little poem of his in which he exclaimed,

Oh, Zinnias,
Most explosive and illuminating
Of flowers,

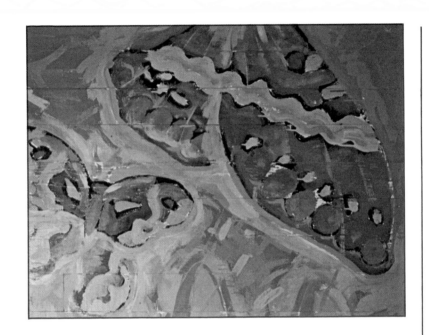

Plate 25
Detail, north wall: moths (space right of chimney).

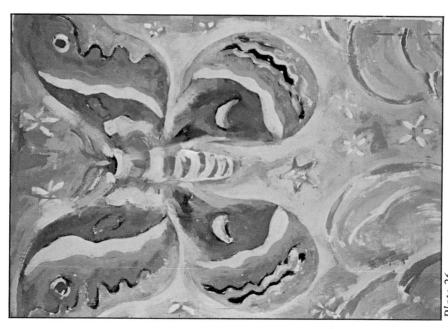

Plate 26
Detail, north wall: Cecropia moth (on upper panel of door).

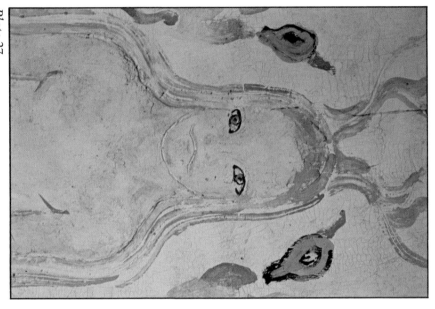

Plate 27
Detail, north wall: "Mary-Mississippi" figure (chimney).

in the watercolor of "Father Mississippi," in which he has not so much painted the subjects—the figure, the trees—as the spaces round the subjects, filling the whole picture space with patterning from which the subjects only partially emerge.

In not painting a figure in a landscape but an environment in which the figure is not more and not less in focus than other elements, Anderson ran strongly counter to humanistic taste and, at a deeper level, to anthropocentric prejudice. In him, humanism was qualified by an environmentalism much more radical than anything which has as yet been expressed by ecologists and conservationists. His attitude was flatly contradictory to the governing view as rendered by Wallace Stevens in his poem, "Anecdote of the Jar," which has been a sort of cultural shibboleth. Stevens recounted placing a round jar upon a hill in Tennessee. The result was

It made the slovenly wilderness
Surround that hill.

Not so with Anderson's sculpture in the woods at Ocean Springs: he would not, in the first place, have characterized wilderness as "slovenly" and had no desire to render wilderness, as Stevens' jar did, "no longer wild." The jar "took dominion everywhere," quite according to what Anderson referred to as "the dominant mode on shore." He would see, as Stevens did, that "The jar was gray and bare," and he would be, if anything, more frankly dismayed in noting that the jar, symbolizing the human element,

did not give of bird or bush,
Like nothing else in Tennessee.

Anderson took his attitude to the length of integrating himself corporally during his union with Horn Island. There he sought "images" by merging his body in surf or lagoon, by burrowing into the sand of the beach, by crawling on his belly through bush and palmetto, by rowing his skiff through the gulfs of the sea, by clinging to the limbs of trees, by giving himself up on a climactic occasion in the last year of his life to experience of hurricane on his island. He begged nothing less than "acceptance" *into* nature, provided only he might carry with him the consciousness necessary to perform what he regarded as his natural function, helping nature to "realize" herself by painting the images with which Providence rewarded his suit.

He left a watercolor of himself physically absorbed into nature (**Plate 29**). He has painted himself lying naked in what he liked to call a nullah—the word is of Hindu derivation—that is, a large puddle or boggy place. He would lie on his back in shallow water and mud, holding still until the diverse life in the nullah accepted him and resumed its normal ways. If then a minnow nibbled at his nipple or a dragonfly perched on his prominent nose, he was delighted. Even if a snake slithered away in the mud beneath him, he restrained the impulse, dating from the Fall, to leap up or bruise its head.

The relation between the watercolors of "Father Mississippi" and of the artist in the nullah runs deeper than the similar treatments of the male figures merged into nature. They

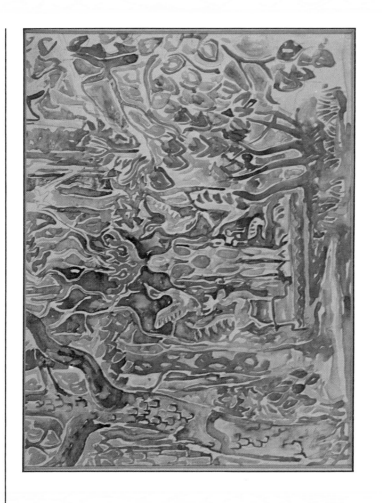

Plate 28
Watercolor by Walter Anderson of his wood sculpture, "Father Mississippi."

page fifty-seven

are not pictures of static circumstance but of passionate inter-course. Now during his youth in New Orleans, Anderson devel-oped a feeling for the Mississippi River which in adulthood he transferred to the Mississippi Sound. He made himself a denizen of the great stream, in which he swam and sailed; twice he descended the Ohio and Mississippi rivers by canoe. The second of these trips was his delayed honeymoon journey in 1935, an extraordinarily acted-out instance of his desire to combine in passionate embrace nature and human nature. During the years of alienation, he re-treated from the human in order to satisfy his painter's passion for the images of nature. But in the mural at the end of his life he reintroduced the human, indeed seemed to make it dominant in landscape, in the feminized version of Father Mississippi on the chimneypiece.

This figure functions in two ways in the mural. Taken as the Mississippi River, the figure functions as it were geograph-ically to confirm the organization of the mural according to the phases of light during the 24 hours. Set against the north wall, the figure neatly divides the east from the west segments of the mural and the stream may be taken as flowing properly southward. This interpretation is guaranteed by the subjects Anderson painted on the projecting sides of the fireplace: on the west, roadrunners and cactus; on the east, a Turk's cap lily, a turkey gobbler, and what is called in that liveoak country an "eastern" oak leaf (Plates 30 and 31).

The second function of the figure on the chimneypiece will become apparent when it is understood that in feminizing it Anderson gave it the face of either his young wife or his eldest

child, their daughter Mary. The Anderson family thinks the face is Mary's, but Mary and her mother resemble each other in any case and I cannot forget the association between the Mississippi and Anderson's honeymoon trip. One might, of course, postulate a connection with the daugher since the little painted room was originally built as her nursery. Either way, the man so oppressed, as he wrote, by "the dominant mode on shore," embodied as that was in wife, family, and social responsibilities, that he found "it was necessary for me to go to sea to find the conditional" and became the withdrawn "Islander," came in the end to paint nature on the walls of his house and enshrine the human connection.

In doing this, Walter Anderson demonstrated affinity with, even if the evidence is only circumstantial that he consciously endorsed, the transcendent sanity of the psalmist, whose praise of the creation so matter-of-factly includes the human part of it. The rubric describes Psalm CIV as a "meditation upon the majesty and providence of God," and the psalmist did not take it upon himself to reject any dispensation of that majesty and providence. The divine light orders the life of man as wisely as that of the plants and beasts. God no more "causeth the grass to grow for the cattle" than he does the

> herb for the service of man:
> that he may bring forth food out of the earth;
> And wine that maketh glad the heart of man, and oil to make his face to shine, and bread which strengtheneth man's heart.

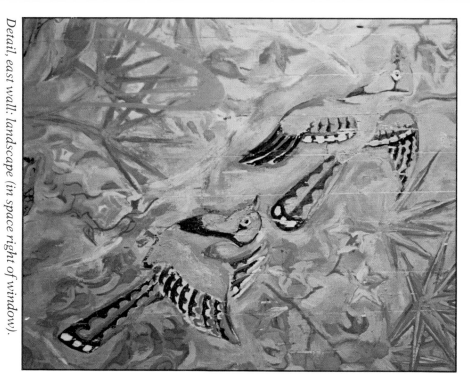

Detail, east wall: landscape (in space right of window).

Plate 8

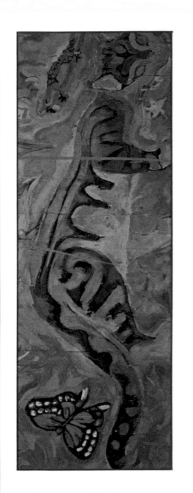

Plate 9
Detail, east wall: cat (ground beneath window).

perhaps in some instances, totemistic symbols that stress the framing of the views. The design of each windowed wall falls into five spaces, those to the left, right, above, below, and *through* the window. I shall argue below that this powerful outward and objective orientation must be understood as integral to the meaning of the mural, and as a painterly analogue of the psalmist's glorification of the works of the Lord.

It therefore was essential that this effect be properly captured by the camera. Michael's problem was to photograph the walls with artificial light and the scenes beyond the windows in daylight, while maintaining exposure and color balance correct for both. He decided against using tungsten light because it created color temperature inside that differed from that of daylight. Tungsten light would also have produced a difference in exposure. Instead, he used strobe light, which has about the same color temperature as daylight.

He determined the exposure by first determining the f-stop for the exposure proper for the inside walls, and then took a light meter reading for the area outside the windows in daylight. The shutter speed opposite the f-stop used for the inside walls matched the two exposures. Since he used strobe light, the changing of the shutter speed had no effect on the inside exposure; the strobe light duration was shorter than 1/1000 second. The strobe light captured the artist's colors accurately with daylight Ektachrome film, and Michael used a 4x5 view camera with a wide-angle lens to keep the wall square so that the entire wall could be photographed. The panels of the Foldout are printed nearly the size of the negatives to insure maximal faithfulness to the colors of the mural and

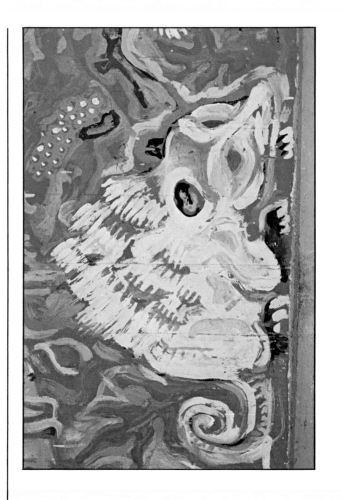

Plate 10
Detail, east wall: possum.

minimal distortion.

It should be noted further, with respect to the panels of the Foldout, that Michael could not obtain perfectly even lighting over the entire surface of each wall. He had only two studio strobes with 16" reflectors and could not use the standard 45-degree angle because of the smallness of the room. He placed the lights at each side of the corner and angled toward the far corner. The photographs show a slight light fall-off at the corners of the room. Nevertheless, readers will see truer color and more detail than many visitors to Anderson's cottage do, for the lighting of the little room varies with the seasons and time of day.

As one follows the mural around the corner from the east to the south wall, one is approaching noon and looking inland. The squall has passed, and a rainbow binds the east segment to the south segment (Foldout, panel 2). An osprey is in flight—that species to which, as it was to Walter Anderson, Horn Island is an indispensable haven—while closer to one in the midsection of the space left of the windows one may identify a heron and two flying insects, the first perhaps a wasp moth and the other unmistakably a dragonfly. A bird, which may be a titmouse, is to be seen at the extreme left. A spider has spun its web (Plate 11). In the space above the windows, Anderson painted clouds, presumably in the aftermath of the storm, which glow with color in the noonday sun and make one of the most distinctly Impressionist effects in the work (Plate 12).

Below the south windows is marshy ground, upon which are basking a turtle and a frog to the left. An alligator occupies the central part, and one is tempted to say Anderson included him as

the Gulf Coast analogue of that great Leviathan to which the psalmist calls admiring attention. Small butterflies and mushrooms add their decorative forms and colors, and beyond the alligator's snout are a skink touched with scarlet, a rabbit, a towhee, and another rabbit.

The south wall, being wider than the east and west walls, accommodates a double window, and the outward view is accordingly more expansive. It occupies a proportionally greater part of this segment of the mural. One looks out into dense foliage, wherein a patient eye will detect variety of animal, bird, and insect life as it does on the painted wall within. This is a work of art not composed and framed to concentrate attention upon its own delimited space and selected subject matter but opened expansively at its center to environing nature, its subject, but of which it is only one element like another (Plates 13, 14, 15, 16 and 17).

A shallow stream seems to curve out from behind the double window to end in cross-section at the lower right. A flock of ibis flies in the upper right corner. It looks like late afternoon, and a deer, perhaps standing in for the psalmist's wild asses, has come down to drink at evening. There is a redwing blackbird to the right of the windows, repeating the pair at the lower left. In the stream, a gallinule and two coots are feeding while two fish swim at one's feet, and a bittern perches in stalks just across the stream (Plates 18 and 19).

The west wall, with the painted sunset glowing from behind and above its single window, is composed like the east wall so that at the right instant the actual sun should appear in the window. Animals, birds, and insects are more incidental to light and

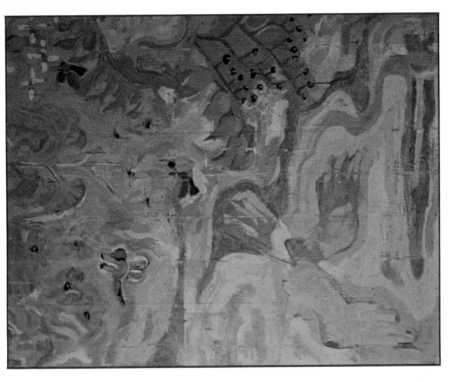

Detail, south wall: landscape (left of double windows).

Plate 11

Plate 12
Detail, south wall: sunlit clouds (above double windows).

CENTER FOLDOUT:
Panel 1: East wall of mural in Walter Anderson's cottage.
Panel 2: South wall.
Panel 3: West wall.
Panel 4: North wall.

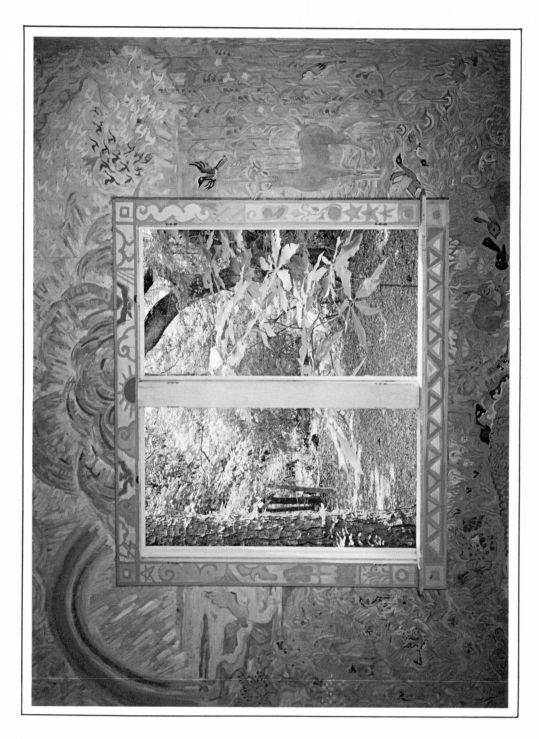

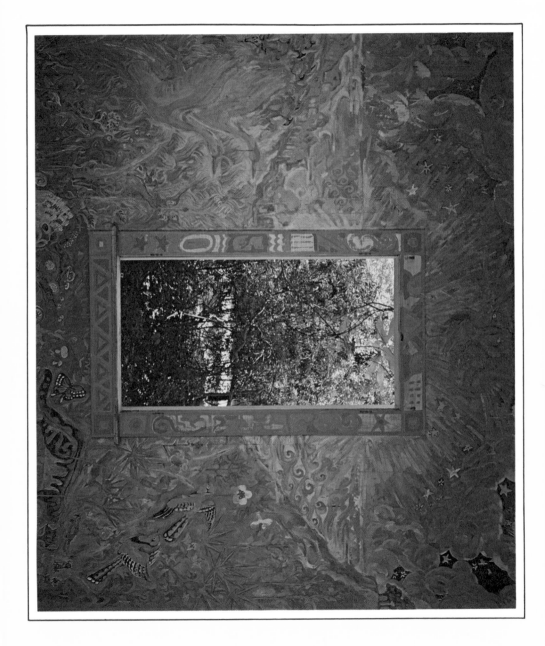

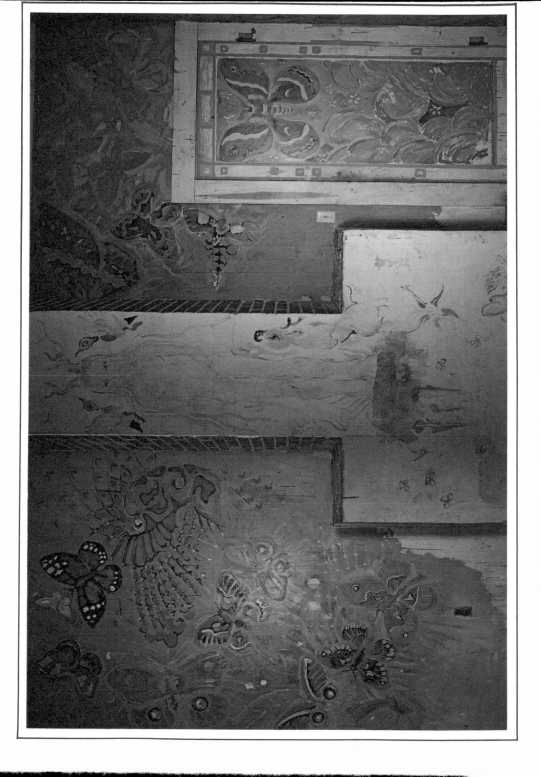

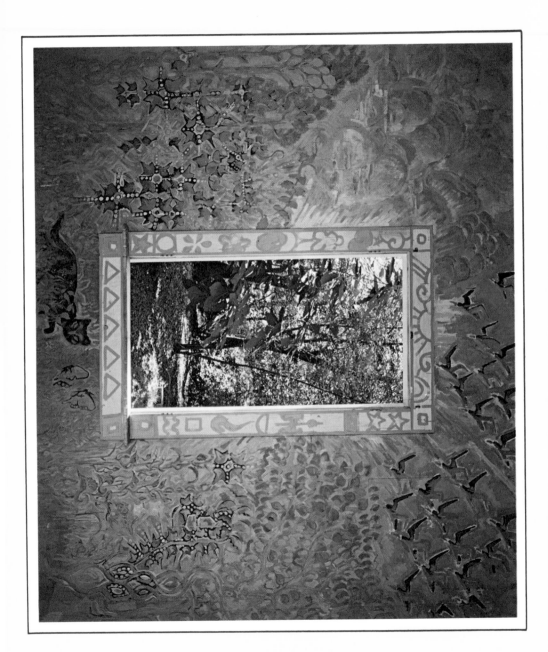

vegetation here than in the first two segments (Foldout, panel 3). In the receding perspective beneath the west window, another cat—and cats were likely to appear anywhere in Anderson's work in any kind—appears, this one setting out for night life as the one on the east wall is returning. Ahead of the cat are butterflies, apparently a spice bush swallowtail and a hairstreak (Plate 20). Flocks of shearwaters, as black skimmers are locally called, seem to be pouring into the setting sun from the upper right corner.

The dominant vegetable motifs here—pine boles to the left, the blue flowers which may be moonflowers on both sides of the window, and on the right a small tree laden with fruit, which looks like persimmon, and a wild grapevine—merge with the rendering of the sunset in a more purely coloristic effect than obtains for the other three walls. One is reminded of an observation of Anderson's to the effect that "the world is organized by color," a view quite compatible with the psalmist's view that the world is organized by light (Plates 21 and 22).

The east, south, and west segments of the mural share the feature of fenestration, which Anderson used in the composition to unite the three walls and set them apart from the north wall. This is dominated, not by a window used to lead the eye outward, but by the back of the chimney and fireplace projecting inward. Although the grand design of organizing the mural according to the successive phases of light has been carried out, the time of the north wall being night, Anderson took advantage of the unique structural feature, the chimneypiece, to introduce in a specially emphatic way a new element, the human.

The goddess-like female figure sketched but not com-

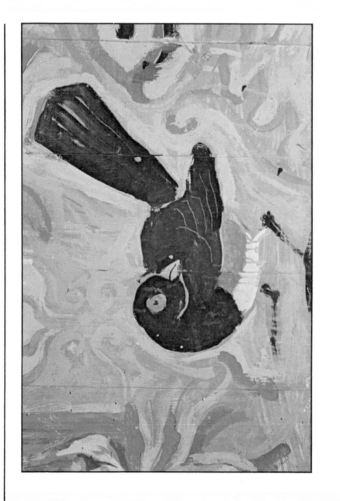

Plate 13
Detail, south wall: bird (beneath double windows).

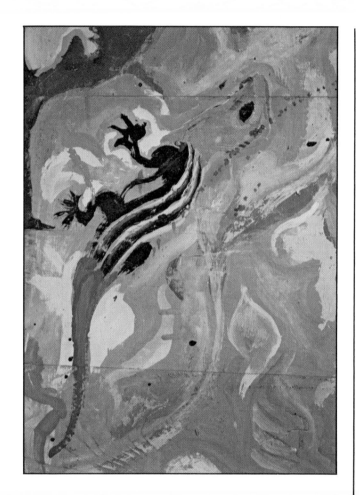

Plate 14
Detail, south wall: skink.

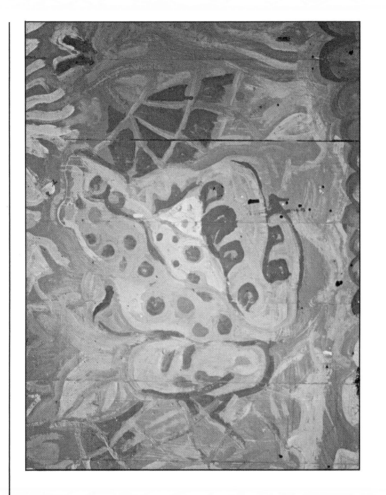

Plate 15
Detail, south wall: frog.

Plate 16
Detail, south wall: alligator.

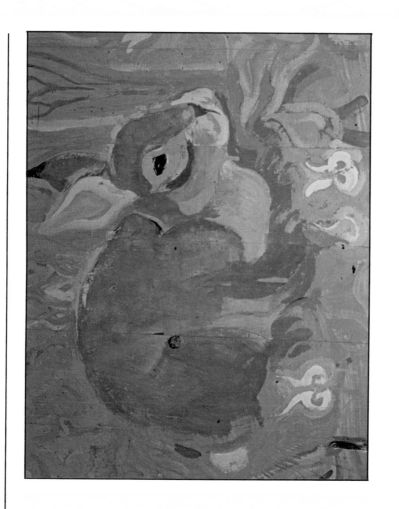

Plate 17
Detail, south wall: rabbit.

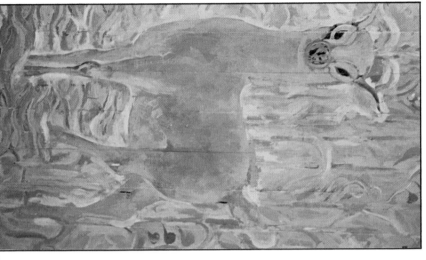

Plate 18

Detail, south wall: landscape (to right of double windows).

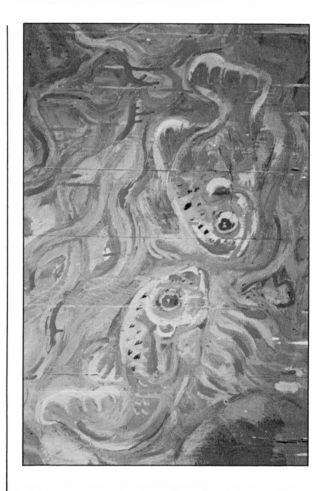

Plate 19
Detail, south wall: fish swimming in stream.

pletely painted on the chimney is gigantic in the scale of the landscape on the other three walls. Her prominence in the total composition, guaranteed by her location on a surface projecting into the room in contrast to the transmural effect of the windows, is further enhanced by the replacement of landscape as background by a display of moths, also gigantic, against the dark night air. Anderson kept the emphasis on the projecting chimneypiece by continuing the overall moth motif on the door leading into the main room of the cottage, thus preventing a sense of another opening that would compete as a structural feature (Foldout, panel 4).

The north wall memorializes happy occasions when the Anderson family went mothing. Mrs. Anderson says they painted tree trunks in the late evening with sugar and beer and then after dark used a floundering light and "reaped our drunken harvest." Beginning in the upper left corner, Anderson painted the forester or peach moth, the rare Composia fidelissima in its elegant midnight blue with red at the shoulders and white spots bordering the wings, and—just next the chimney, and viewed apparently from beneath—the Morpho moth. The two small pale blue moths at the top I have been unable to identify. Conceivably, since the north wall is unfinished, Anderson did not complete these. In a diagonal roughly parallel to the top group, Anderson has disposed, from left to right, a female io, a buck, and a male io. Then in a third diagonal arrangement below these, he placed a Polyphemus, another buck, and a Cecropia, while in the lower left corner appears what seems to be a small rose moth, balancing a pair of the same species above the door to the right of the chimney (Plates 23 and 24).

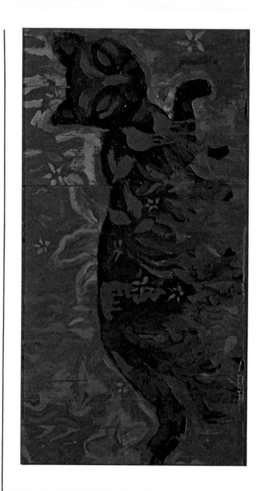

Plate 20
Detail, west wall: cat (in space beneath window).

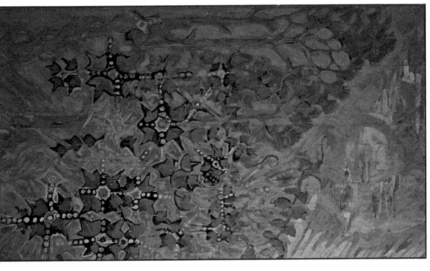

Plate 21

Detail, west wall: pine boles and moonflowers (in space left of window).

Plate 22
Detail, west wall: persimmon trees (in landscape right of window).

The other moths to the right of the chimney, beginning at the top, are a great odarata painted in profile with wings folded, an Ailanthus, and a Sphinx, while a Cecropia is spreading its wings in full glory on the upper panel of the door. Dimly visible in the night above the right upper corner of the door an Imperial moth is flying (Plates 25 and 26).

But the most signal aspect of the north wall is the unfinished fresco on the plastered back of the chimney and fireplace (Plate 27). This relates at once to intimate details of the artist's life and mind and, as I am persuaded, supplies a final allusion to Psalm CIV. The female figure is an interestingly revised version of a large wood sculpture called "Father Mississippi" that Anderson carved sometime in the early 1950s. Except for a few elements, this has not survived; a color snapshot of it exists, however. Anderson did a watercolor of it which helps to illuminate several aspects of the mural.

"Father Mississippi" was a group of flora and fauna of the stream, the banks, and the air surrounding a totem-like male figure representing the Mississippi River. Carved from a log, he stood about eight feet high. His head was crowned with reddish brown antler-like forms representing tributary streams which, merging with his long hair and beard, flowed down his blue body to his feet. On either side of his head, a mallard hovered, wings vertical, to give an heraldic effect. The creatures and plants assembled about Father Mississippi on a low platform were detachable and changed from time to time when Anderson sold or gave away one or another.

In the photograph, the group included, to the right of the

central figure, a buck deer and another Anderson cat. To its left, viewing from the bottom upward, were a possum, a gull, some mallows or perhaps thistles, a great blue heron, and a blue jay. There was also what looked like a gull. The front of the platform, like the stream on the south wall of the mural, represented the river in cross section. It was bordered by a narrow scalloped strip, painted reddish brown, representing wavelets, beneath which, in blue water, swam four fish cut from thin boards. As a comparison of this account with Plate 27 will show, Anderson was faithfully reproducing from memory this group sculpture when he painted the chimney in the cottage, except for the change of sex in the central figure. The reddish smudge at the feet of the figure on the chimney was not put there by the artist but developed, no doubt as an effect of the hot damp climate, sometime after 1966, when a color photograph was made which does not show the discoloration.

Something essential to complete understanding of the mural is to be gained, I believe, from study of the watercolor Anderson painted of his sculpture of "Father Mississippi" (Plate 28). The material points are the setting he provided for the sculpture and, more particularly, the way he rendered this work-in-its-setting in the watercolor. The sculpture stood in the woods outside his cottage, a human creation merged in nature, not set apart in the traditionally humanistic way in dominant contrast to nature. The cottage happens to stand thus; and I believe that in emphasizing the view outward through the windows in the mural Anderson further exemplified this taste, amounting to passion, for integrating the human with the natural. The effect is unmistakable

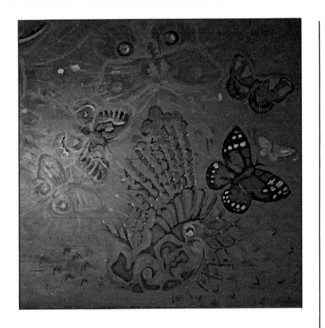

Plate 23
Detail, north wall: space left of chimney.

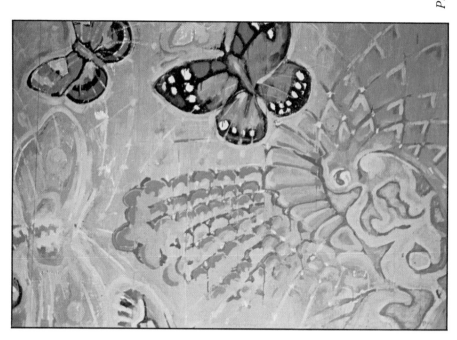

Plate 24

Detail, north wall: Composia fidelissima moth.

Plate 25
Detail, north wall: moths (space right of chimney).

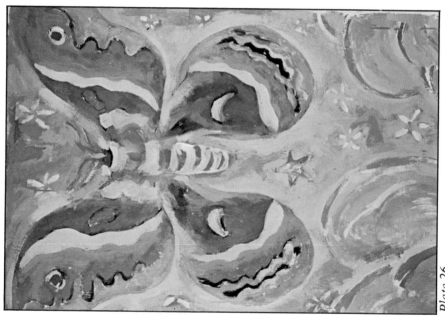

Plate 26
Detail, north wall: Cecropia moth (on upper panel of door).

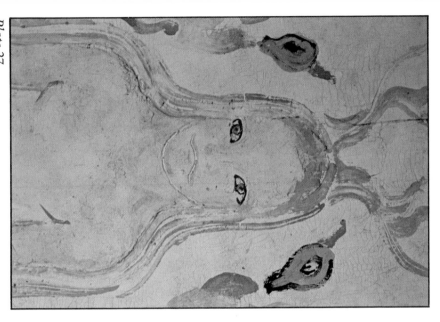

Plate 27
Detail, north wall: "Mary-Mississippi" figure (chimney).

in the watercolor of "Father Mississippi," in which he has not so much painted the subjects—the figure, the trees—as the spaces round the subjects, filling the whole picture space with patterning from which the subjects only partially emerge.

In not painting a figure in a landscape but an environment in which the figure is not more and not less in focus than other elements, Anderson ran strongly counter to humanistic taste and, at a deeper level, to anthropocentric prejudice. In him, humanism was qualified by an environmentalism much more radical than anything which has as yet been expressed by ecologists and conservationists. His attitude was flatly contradictory to the governing view as rendered by Wallace Stevens in his poem, "Anecdote of the Jar," which has been a sort of cultural shibboleth. Stevens recounted placing a round jar upon a hill in Tennessee. The result was

It made the slovenly wilderness
Surround that hill.

Not so with Anderson's sculpture in the woods at Ocean Springs: he would not, in the first place, have characterized wilderness as "slovenly" and had no desire to render wilderness, as Stevens' jar did, "no longer wild." The jar "took dominion everywhere," quite according to what Anderson referred to as "the dominant mode on shore." He would see, as Stevens did, that "The jar was gray and bare," and he would be, if anything, more frankly dismayed in noting that the jar, symbolizing the human element,

did not give of bird or bush,
Like nothing else in Tennessee.

Anderson took his attitude to the length of integrating himself corporally during his union with Horn Island. There he sought "images" by merging his body in surf or lagoon, by burrowing into the sand of the beach, by crawling on his belly through bush and palmetto, by rowing his skiff through the gulfs of the sea, by clinging to the limbs of trees, by giving himself up on a climactic occasion in the last year of his life to experience of hurricane on his island. He begged nothing less than "acceptance" *into* nature, provided only he might carry with him the consciousness necessary to perform what he regarded as his natural function, helping nature to "realize" herself by painting the images with which Providence rewarded his suit.

He left a watercolor of himself physically absorbed into nature (Plate 29). He has painted himself lying naked in what he liked to call a nullah—the word is of Hindu derivation—that is, a large puddle or boggy place. He would lie on his back in shallow water and mud, holding still until the diverse life in the nullah accepted him and resumed its normal ways. If then a minnow nibbled at his nipple or a dragonfly perched on his prominent nose, he was delighted. Even if a snake slithered away in the mud beneath him, he restrained the impulse, dating from the Fall, to leap up or bruise its head.

The relation between the watercolors of "Father Mississippi" and of the artist in the nullah runs deeper than the similar treatments of the male figures merged into nature. They

Plate 28
Watercolor by Walter Anderson of his wood sculpture, "Father Mississippi."

are not pictures of static circumstance but of passionate intercourse. Now during his youth in New Orleans, Anderson developed a feeling for the Mississippi River which in adulthood he transferred to the Mississippi Sound. He made himself a denizen of the great stream, in which he swam and sailed; twice he descended the Ohio and Mississippi rivers by canoe. The second of these trips was his delayed honeymoon journey in 1935, an extraordinarily acted-out instance of his desire to combine in passionate embrace nature and human nature. During the years of alienation, he retreated from the human in order to satisfy his painter's passion for the images of nature. But in the mural at the end of his life he reintroduced the human, indeed seemed to make it dominant in landscape, in the feminized version of Father Mississippi on the chimneypiece.

This figure functions in two ways in the mural. Taken as the Mississippi River, the figure functions as it were geographically to confirm the organization of the mural according to the phases of light during the 24 hours. Set against the north wall, the figure neatly divides the east from the west segments of the mural and the stream may be taken as flowing properly southward. This interpretation is guaranteed by the subjects Anderson painted on the projecting sides of the fireplace: on the west, roadrunners and cactus; on the east, a Turk's cap lily, a turkey gobbler, and what is called in that liveoak country an "eastern" oak leaf (Plates 30 and 31).

The second function of the figure on the chimneypiece will become apparent when it is understood that in feminizing it Anderson gave it the face of either his young wife or his eldest

child, their daughter Mary. The Anderson family thinks the face is Mary's, but Mary and her mother resemble each other in any case and I cannot forget the association between the Mississippi and Anderson's honeymoon trip. One might, of course, postulate a connection with the daughter since the little painted room was originally built as her nursery. Either way, the man so oppressed, as he wrote, by "the dominant mode on shore," embodied as that was in wife, family, and social responsibilities, that he found "it was necessary for me to go to sea to find the conditional" and became the withdrawn "Islander," came in the end to paint nature on the walls of his house and enshrine the human connection.

In doing this, Walter Anderson demonstrated affinity with, even if the evidence is only circumstantial that he consciously endorsed, the transcendent sanity of the psalmist, whose praise of the creation so matter-of-factly includes the human part of it. The rubric describes Psalm CIV as a "meditation upon the majesty and providence of God," and the psalmist did not take it upon himself to reject any dispensation of that majesty and providence. The divine light orders the life of man as wisely as that of the plants and beasts. God no more "causeth the grass to grow for the cattle" than he does the

herb for the service of man:
that he may bring forth food out of the earth;
 And wine that maketh glad the heart of man, and oil to make his face to shine, and bread which strengtheneth man's heart.

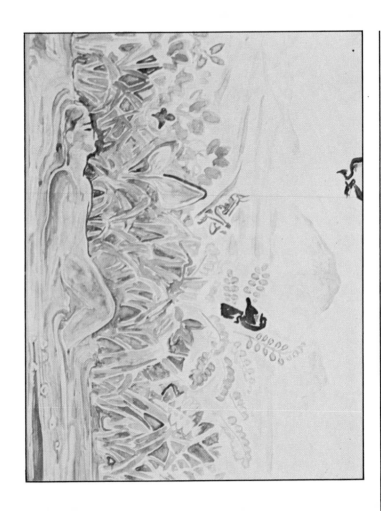

Plate 29
Watercolor by Walter Anderson of himself lying in a nullah.

But the mural is a *painter's* psalm, and it remains to relate to it Anderson's unique theory and practice as a painter; for the mural seems to epitomize these. The lyric "Oh, Zinnias" may be taken as a key. In the last two lines, Anderson used the terms "the eccentric"—there eccentrically spelled "excentric"—and "the concentric," which are part of the technical vocabulary of his private philosophy. When, at the beginning, I spoke of Anderson's cottage as the hermitage of eccentric genius, I meant to foreshadow this concluding discussion and hint a parallel between Anderson's eccentricity and what I have characterized as the transcendent sanity of the psalmist. This implies not only joyous acceptance of the human along with every other part of the creation but an appreciation of Providence.

Anderson was a voyager out of society and into nature by foot and bicycle as well as by skiff and kept logs of his excursions not only to Horn Island but to various other places. In a log of a bicycle trip through part of the South, during which he frequented many a nullah, he jotted down in the gnomic style he liked, this observation: "No is the concentric." The context makes it plain that this is humorous, as Anderson often was—No was certainly not given to reclining in mud holes, and might have his point. Nevertheless, the saying was part of an argument: If No is the concentric, then Yes must be the eccentric. Had not Walter Anderson been put down as so eccentric as to be certified schizophrenic? The references were to attitudes toward the world, negation identified with the humanly oriented, the anthropocentric, and affirmation with the naturally and objectively oriented.

Even at his most eccentric, however, Anderson had a sav-

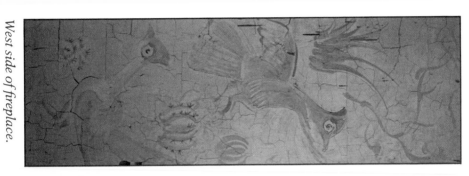

West side of fireplace.

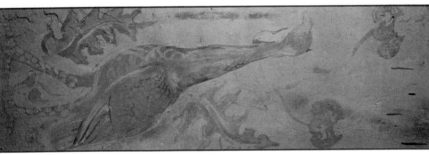

East side of fireplace.

Plate 30 Plate 31

ing relation to Providence although he might dangerously attenuate the relation with humankind. Readers of *The Horn Island Logs* know how providential he regarded his status as an "islander" to be. The island was accessible, he said, "only to celestial beings, but Providence made an exception in my case." He thought of himself as returning the favor with affection, praise, and assistance, Providence sometimes needing, in his opinion, help in ordering the world to everybody's complete satisfaction. Sometimes, when Providence had been especially efficient in providing the images he needed, Anderson acknowledged his debt by painting into his pictures an eye-like symbol (Plate 32). While the zinnia on the ceiling of his little room refers, probably, more to the source of governing light, it may be thought of as an analogue of the providential eye of the watercolor.

Mrs. Anderson has recently noticed, scribbled on the back of a watercolor of a great blue heron, another observation in which the special usage of eccentricity and concentricity occurs. "Fear," Anderson wrote, "is either unity or chaos—if all of the faculties are brought together for the sudden effort, it is unity—if they disintegrate it is chaos. If in the single unit both eccentric and concentric forces go into the construction, they balance each other and the machine would not function." This testifies to his consistent association of the eccentric with the objective, celebratory orientation and the concentric with the humanly subjective. I infer that as a painter he tried to rule out the latter though this involved very nearly ruling out human relationships altogether; otherwise, he said, "the machine would not function." Only at the center and source of governing light, symbolized in his mural by the zinnia,

could he conceive of "both eccentric and concentric forces" going into the construction in a functional way.

I suggest that in the mural Anderson used the fenestration that happened to be a structural feature to bring the eccentric forces into the construction and the chimneypiece that happened to project into the space to do honor at last to the concentric forces. The mural renders without resolving the tension. Some people are discomfited by this effect as they are by similar effects in his most characteristic watercolors: they need focused human interest. Most viewers, however, respond to Anderson's "eccentricity" as joyous affirmation of the world, all the more poignant in over-balancing, as in the mural, the equally profound values of "concentricity." For the Mary-Mississippi figure is after all unfinished and not so much part of the mural as set against it. One speculates whether the figure was left unfinished for lack of time or interest or whether he did not find it impossible, late and soon, to balance the conflicting forces "in the single unit." That is, surely, a way of phrasing the universal human predicament, and everybody can sympathize with Anderson's facing it even though he went to sea, as he said, to seek "the conditional" while the rest of us stayed home and nursed the definitive or an illusion thereof.

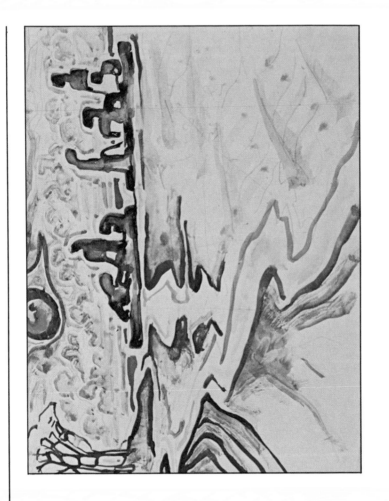

Plate 32
Horn Island watercolor by Walter Anderson showing symbol of Providence.

WALTER INGLIS ANDERSON

Chronology

1903	Born at New Orleans, September 29
1923	Parsons Institute, New York City
1924-28	The Pennsylvania Academy of the Fine Arts, Philadelphia
1925	Packard Award for animal drawing at the Pennsylvania Academy
1928-29	Travel and study in France on Cresson Award from the Pennsylvania Academy
1935	Mural, Ocean Springs, Mississippi, High School (W.P.A. commission)
1937	Mural, Indianola, Mississippi, Post Office (W.P.A. commission never completed due to illness)
1944	Exhibition of Shearwater Pottery by Peter Anderson, decoration by Walter Anderson, Brooks Memorial Art Gallery, Memphis, Tennessee
1949	Exhibition of block prints, Brooklyn Museum, Brooklyn, New York
1950	Mural, Town Hall, Ocean Springs
1952	Travel in China
1961?-65	Travel in Costa Rica
	Mural in cottage at Ocean Springs
1964	Exhibition of watercolors of fledgling birds, Brooks Memorial Art Gallery
1965	Died in New Orleans, November 30
1967	Retrospective Traveling Exhibition, "The World of Walter Anderson," Brooks Memorial Art Gallery, Memphis, including

ceramics, drawings, oils, prints, sculpture, and watercolors

1973 Publication of *The Horn Island Logs of Walter Inglis Anderson,* edited by Redding S. Sugg, Jr.

1978 Telecast of *The Islander,* a half-hour documentary film based in part on *The Horn Island Logs,* over the Public Broadcasting System